FAMOUS FLOWERS
IN CHINA

TITLES IN THE SERIES

Chinese Ceramics
JI WEI

Chinese Characters
NINA TRAIN CHOA

Chinese Calligraphy
ZHOU KEXI

Chinese Painting
DENG MING

Chinese Tea
LING YUN

50 Amazing Places in China
DONG HUAI

56 Ethnic Groups in China
DAI DUNBANG

Famous Flowers in China
QIAN XINGJIAN

Discovering China

FAMOUS FLOWERS IN CHINA

PAINTINGS BY QIAN XINGJIAN

Reader's
Digest

The Reader's Digest Association, Inc.
Pleasantville, New York / Montreal / Sydney

FOR SHANGHAI PRESS & PUBLISHING DEVELOPMENT COMPANY
Managing Directors: Wang Youbu, Xu Naiqing
Editorial Director: Wu Ying
Editors (Chinese): Ying Xinhua, Ding Feng
Editor (English): Kirstin Mattson
Assistant Editor (English): Yao Feng

Foreword by Zhu Junbo
Introduction by Xu Jianrong
Paintings by Qian Xingjian
Text by He Xiaoyan
Translation by Cao Jianxin

Cover Design: Wang Wei
Interior Design: Yuan Yinchang, Li Jing, Hu Bin

Library of Congress Cataloging-in-Publication Data

Qian, Xingjian.
Famous flowers in China / Qian Xingjian.
 p. cm.
ISBN 978-1-60652-156-4 (alk. paper)
1. Qian, Xingjian–Themes, motives. 2. Flowers in art. 3. Flowers–China. I. Title.
ND2070.C454A4 2009
759.951–dc22
 2009036921

FOR READER'S DIGEST
Executive Editor, Trade Publishing: Dolores York

THE READER'S DIGEST ASSOCIATION, INC.
President and Chief Executive Officer: Mary Berner
President of Asia Pacific: Paul Heath
President and Publisher, U.S. Trade Publishing: Harold Clarke

Printed in China by Shanghai Jielong Art Printing Co. Ltd.

1 3 5 7 9 10 8 6 4 2

CONTENTS

CONTENTS

FOREWORD

As an integration of both the tradition of Chinese painting skills and the essence of Western arts, the Shanghai School of Painting has unfolded an artistic scroll of more than 100 years by means of continuous innovation and great diversification. As one of the classic masterpieces of the Shanghai School of Painting, *Famous Flowers in China* by Mr. Qian Xingjian has offered a brand-new page to the arts of the Shanghai School.

As a representative painter of the Shanghai School in painting flowers and birds, Mr. Qian Xingjian has experienced an artistic practice of more than 50 years: copying ancient works, apprenticing himself to a master, sketching from nature, and painting on his own. His paintings of flowers and birds not only boast solid traditional skills, but also have absorbed the advantages of Western paintings in color and shape, thus featuring the combination of realistic and impressionistic painting as well as the integration of both Chinese and Western style. Unique among contemporary paintings of the Shanghai School, Mr. Qian Xingjian's paintings are reputed among people in the same circle as "a crystallization of unrestraint and subtlety, and a combination of magnificence and unsophistication."

Zhu Junbo

President
Oriental Publishing Center
Publishing Group of China

INTRODUCTION

Famous Flowers in China is a recent masterpiece of Mr. Qian Xingjian, a master of the Shanghai School of Painting in painting flowers and birds. As a disciple of Jiang Hanting, Mr. Qian has been engaged in traditional painting of flowers and birds as well as research into ancient and contemporary painting at home and abroad for dozens of years. He has formed his own unique system by absorbing the strengths of various peers. His paintings are novel, spectacular, elegant and unique.

This album features 36 typical flowers of China. Through a lot of on-the-spot sketching, as well as abstraction, epitomization and exaggeration conducted according to various artistic laws, the author has accurately and vividly demonstrated the buds, stalks and leaves of these flowers, as well as their relationship with seasons and the environment. Furthermore, the author has made a bold innovation on the basis of traditional Chinese techniques. In particular, his treatment of colors is full of modern sensibility. Moreover, he has forged the auspicious connotations and literary associations of flowers into his colors, paintings and images, thus enabling his paintings to look both genuine and fantastic. This album can be regarded as the most excellent production of this painter.

INTRODUCTION

The techniques often applied in traditional Chinese flower-paintings include: "double-outlining and color-application," "no-outlining and dotting-into-images," "flower-outlining and leaf-dotting" and "leaf-outlining and flower-dotting." The technique of "double-outlining and color-application" has been applied to such pictures as Lilium and Rosa rugosa in this album. Different textures of different flowers, branches and leaves have been expressed through the thickness and transition of outlines. Then, the shades of flowers and leaves have been highlighted with different colors.

The technique of "no-outlining and dotting-into-images" has been applied to such pictures as Rhododendron simsii and Paeonia lactiflora. The tip of a brush is dipped with different colors. Through the force and turn of the brush, not only has the outline of flowers and leaves been automatically completed, but also the spirit of the color-change, shadow and moisture of the flowers and leaves has been demonstrated. Before they turn dry, ink or deep-color can be reapplied to make just a few outlines or dots as reminders. The technique of "flower-outlining and leaf-dotting" has been applied to such pictures as Cosmos bipinnatus and Dendranthema morifolium.

INTRODUCTION

In these pictures, the flowers painted by the technique of "double-outlining and color-application" appear gorgeous and resplendent, while the branches and leaves painted by the technique of "no-outlining and dotting-into-images" appear dim and indistinct. With the distinct and the indistinct setting off each other, these pictures offer endless glamour. The technique of "leaf-outlining and flower-dotting" has been applied to such pictures as Camellia japonica. In these pictures, the technique of "no-outlining and dotting-into-images" has been applied to the flowers with a thick color, while the technique of "double-outlining and color-application" has been applied to the branches and leaves with a tenacious texture.

As commented on about the function of paintings of flowers and birds, in *A Collection of Paintings in Xuanhe Period* produced in the Northern Song dynasty, "Paintings of flowers and birds can harmonize people with society through their aesthetic function." Chinese culture always seeks a harmonious realm. The essence of Chinese painting also lies in harmony. Paintings of flowers and birds are exactly the spiritual demonstration of the harmony between people and nature.

Xu Jianrong

Chinese Ink Painter
Professor of the Fine Arts Colleague
of Shanghai University

13

Bauhinia Blakeana

Bauhinia blakeana is an evergreen small tree belonging to Cercideae of Fabaceae. Its height can reach 10 meters, and the shape of its leaves is like the hoof of cattle or sheep. Its large, amaranthine and fragrant flower has five flaps, interspersed with white vein-shape color-patterns. Its florescence lasts from November to the next March. Having originally been discovered in Hong Kong, it is now distributed in such southern provinces and regions as Yunnan, Guangxi, Guangdong, Fujian and Hainan, and it is also planted in Taiwan. In addition, it is also distributed in India and Vietnam.

Bauhinia blakeana has large and gorgeous flowers, and it can bloom for half a year in succession. In warm spring, the flowers of Bauhinia blakeana look as resplendent as the glow of morning. Therefore, it has become a very nice ornamental tree-species in tropical and subtropical zones.

Bauhinia blakeana was first discovered in 1880 in the open country of Kong Sin Wan Tsuen, Pok Fu Lam, on Hong Kong Island. Thanks to its five advantages including long florescence, large flowers, beautiful flower-shape, fresh flower-color and strong aroma, Hong Kong formally designated Bauhinia blakeana as

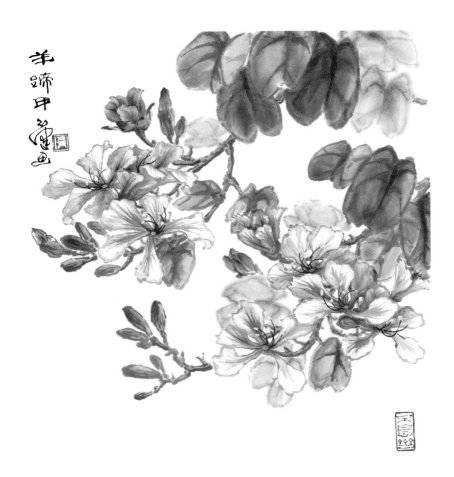

羊蹄甲

梦菡画

its municipal flower. Because of its orchid-like shape and orchid-like fragrance, it is also called "Hong Kong Orchid Tree" in Hong Kong. In 1997, the Hong Kong Special Administrative Region of the People's Republic of China formulated the design pattern of the regional emblem, regional flag and coin with the elements of Bauhinia blakeana. Today, Bauhinia blakeana has become the symbol of Hong Kong.

Camellia Japonica

Camellia japonica is an evergreen shrub and a small tree belonging to Camellia of Theaceae. Its large flower has such colors as red, pink, deep-red, rose, purple, mauve, white, yellow, striped and so on, and its florescence lasts from December to the next April. Having originally emerged in the valleys of the Yangtze River and Pearl River and Yunnan Province in China, Camellia japonica was circulated to Japan in the 7th century for the first time. Since the 17th century, Camellia japonica has been circulated to Europe and America several times, as one of the ten most famous flowers in China.

Roughly speaking, in the Sui and Tang dynasties (581–907 AD), Camellia japonica began to be artificially planted. Camellia flowers in the Tang dynasty (618–907 AD) had only two colors: red and purple. However, in the Song dynasty (960–1279 AD), the varieties and colors of camellia began to increase in number. According to the record in a book, a Camellia japonica even had flowers of ten colors.

Camellia japonica has large, graceful, gorgeous and showy flowers. Although they are as graceful as peonies, they blossom in early winter, which makes them obviously different from peonies.

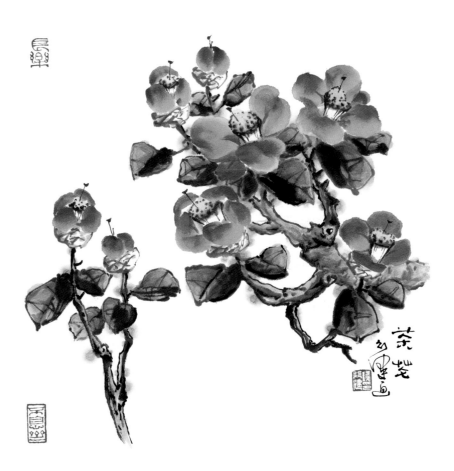

茶花

As a not very cold-resistant flower, camellia cannot suitably grow in the northeast, northwest and north of China due to a frigid climate. It can blossom in winter thanks to the relatively warm and agreeable climate of southern China. However, even in southern China, it will become snowy, stormy and chilly when cold waves come. Therefore, Su Shi (1037–1101), a famous poet in the Song dynasty, sang a high praise of the red camellia flowers blossoming against the frigid winter: "By spreading their fiery warmth amid ice and snow, they can maintain their poses even in freezing winter."

What makes camellia more valuable is that it has a relatively long florescence: It can remain in blossom for several consecutive months throughout the winter and spring, with each flower lasting as long as over 20 days. Most other flowers cannot match it in this regard. Therefore, it is regarded as being elegant and "intelligent," as well as perfect in both image and connotation. In addition, it is eulogized as being as gorgeous as peach and plum flowers, and as noble and virtuous as pines and cypresses.

Camellia Reticulata

Camellia reticulata is an evergreen tree belonging to Camellia of Theaceae. Its height can reach 20 meters. Its large flower contains colors of pink, bright red, mauve, silver and red-and-white. Its florescence lasts from December to the next April. Having originally emerged in Yunnan Province, China, it is planted all over China.

As a specialty of Yunnan Province, China, Camellia reticulata has a graceful tree-trunk, a thick shade, and green flowers as large as cups and as gorgeous as peony. Recognized as a rare flower, it boasts ten features: beautiful flower, lush leaves, tall stem, soft branches, lustrous skin, unique shape, cold-resistance, long life-span, long florescence and fitness for insertion in bottles. Therefore, there is a popular saying, "The Camellia reticulata in Yunnan Province is matchless." Yunnan is the distribution center of camellia plants in the world. There is an extensive open-field plantation in the province, especially in the central area. Camellia reticulata is planted everywhere: in natural scenic spots, pavilions, terraces, temples and public and private courtyards. In many places there are large camellia trees with a history of three to five hundred years. There is a camellia tree in Dali with a history of

山茶華 幻盦

over 1,000 years. Its old trunk is so thick that several persons cannot embrace it together. When in full blossom, the tree is covered with countless flowers. Called "ten thousand Camellia," it is very valuable.

Camellia reticulata begins to blossom in winter, so it is regarded as a winter flower. However, it will not fade away until the end of spring, so it is closely associated with spring at the same time. In Yunnan, Camellia reticulata is more closely associated with spring. It can be said that it is the soul and symbol of the spring of Yunnan. In midwinter, by Dianchi Lake and Erhai Lake, Camellia reticulatas are in full blossom. In spring, Camellia reticulata appears more resplendent in Kunming (a city of spring) and Dali (a city of flowers).

Chimonanthus Praecox

Chimonanthus praecox is a deciduous shrub belonging to Calycanthaceae. Emerging before the leaves, its flower has such colors as light-yellow and gold-yellow, with a waxy quality and a strong aroma. Its florescence lasts from November to the next February. Having originally emerged in central China, it is planted all over China.

Chimonanthus praecox is different from plum: the former belongs to Calycanthaceae, while the latter belongs to Rosaceae. In China, the fame of Chimonanthus praecox is far short of that of plum, because it did not arouse people's attention until in the Tang dynasty, before which it had not had a detailed history of its own. However, the plum had already had a history of application and plantation of several thousand years at that time. However, as Chimonanthus praecox blossoms in frigid winter, earlier than plums, with a stronger aroma than plums, people cannot help marveling at the wonder of Chimonanthus praecox.

Fragrant oil can be extracted from Chimonanthus praecox. Its buds can be used as medicine. Poisonous as they are, its flower-seeds can be used as a purgative, just like croton.

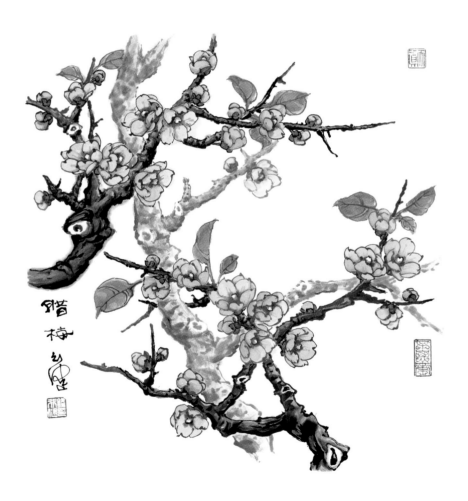

Clivia Miniata

Clivia miniata is a perennial evergreen herbage belonging to Clivia of Amaryllidaceae. It has arrow-shaped leaves that overlap. Its flower has such colors as red and orange. It can blossom all the year round, but mostly in spring and summer. Its flowers can blossom in turn for two to three months. Having originally emerged in southern Africa, it is planted in greenhouses all over China.

The Chinese translation of Clivia miniata (*Junzi* Orchid) originates from nobilis, the Latin scientific-name of one of its varieties (originating from a Latin word meaning "nobility"). In China, a morally superior person is traditionally called *junzi*. Therefore, this translation is very pertinent and vivid. The flowers of Clivia miniata are radiant, enchanting and delicate, but the beauty of Clivia miniata not only lies in its slim and graceful flower-appearance, but also in its sword-like, belt-like, symmetrical, overlapped, emerald and lustrous leaves, as well as its crystalline and translucent fruits. All the leaves, flowers and fruits of Clivia miniata are beautiful and can offer a visual and psychological feast to people. Therefore, there is a saying about "appreciating flowers, fruits and leaves in one, three and four

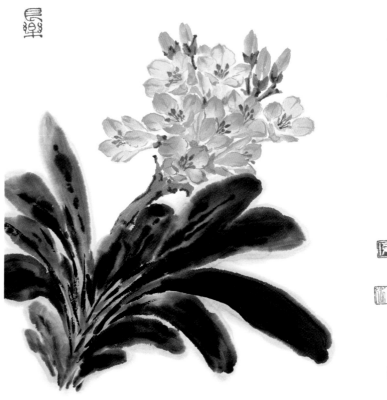

君子蘭 乙丑秋岳錢之庠畫於不息齋

seasons respectively." It is a rare and valuable flower for long-term appreciation.

In the opinion of Chinese people, the flowers of Clivia miniata are replete and gorgeous, symbolizing richness, nobility, auspice, prosperity, happiness and affluence. The sword-like leaves of Clivia miniata symbolize adamancy, fortitude and unyieldingness.

Cosmos Bipinnatus

Cosmos bipinnatus is also called Gesang Flower, meaning a flower of happiness in Tibetan, Gesang Flower is not a specific flower. Tibetan people call all the wild flowers on the Tibetan Plateau Gesang Flower. These flowers chiefly include: Cosmos, alias Qiuying and Persian Chrysanthemum, an annual herb belonging to Asteraceae, with red, white, pink and purple flowers; Potentilla fruticosa, alias Jinlaomei and Jinlamei, a deciduous shrub belonging to Rosaceae, with yellow flowers; Primula malacoides, a perennial herb belonging to Primulaceae, with deep-red, purely-white, emerald, purple-red and light-yellow flowers; Gentiana, a perennial herb, with dark-green, blue or light-green flowers; Rhododendron, alias Yingshanhong and Wild Red Flower, an evergreen or deciduous shrub belonging to Ericaceae, with red, purple, yellow, white, light-blue and light-green flowers; and Alpine Orchid, Stellera chamaejasme, and so on. These flowers have a different florescence, and most of them blossom from spring to autumn. They grow wildly in such regions as the Qinghai-Tibet Plateau.

These flowers growing on the plateau are herbs or shrubs, with a stalk-height of no more than one meter, slim and small

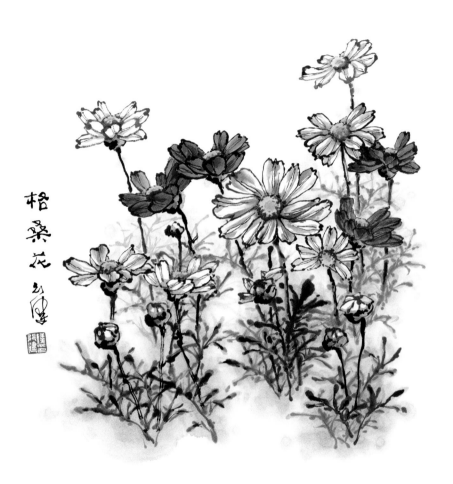

格桑花

branches and limbs, as well as thin petals. They look commonplace and fragile, but they will remain upright, green and gorgeous in spite of raging storms, heavy rain or scorching sunlight. They boast a very strong adaptability to the environment. They multiply everywhere in regions with a high altitude. Whenever they blossom, they decorate and adorn the snow-covered plateau vividly and elegantly with their omnipresent flowers.

Gesang Flower is the most beautiful flower in the eye of Tibetan people. In many Tibetan songs, hardworking and beautiful girls are often compared to Gesang Flower, which symbolizes adamancy, auspice, friendship and love. As a token of the plateau, Gesang Flower has become a holy and sacred flower most favored by Tibetan people.

Cymbidium Goeringii

Cymbidium goeringii is a perennial evergreen herbage belonging to Cymbidium of Orchidaceae. It has belt-like and sword-like leaves, three-calyx flowers and a balmy smell. Its florescence lasts from February to March. Having originally emerged in China, it is chiefly distributed in the valley of the Yangtze River and in southwestern China. It is one of the ten most famous flowers in China.

The orchid has been regarded as the most aromatic flower since the ancient times. Therefore, it is also called "national fragrance," "king of fragrance," "founder of fragrance" and "the first fragrance."

Chinese people worship orchids very much, which has something to do with a statement of Confucius (551–479 BC): "Orchids living in dense forests give out their fragrance despite there being no people there; *junzi* (virtuous people) who always temper their characters and morality will not surrender to poverty." Orchids growing in quiet valleys do not want to become illustrious, but can reform the world with their aroma. Doesn't this resemble the character of a *junzi*? Therefore, by associating orchids with virtuous persons, Confucius proposed that persons

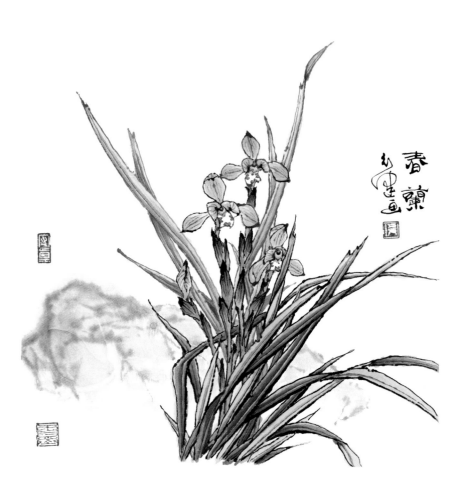

春蘭

32

should emulate and learn from orchids while living in this world, so as to temper their faithful and lofty sentiments instead of seeking fame and wealth. To numerous students deeply immersed in Chinese traditional thoughts and cultures, who is unwilling to pursue the gentlemanlike style of orchid?

People call the orchid *junzi* because it symbolizes virtuousness. Painters love to call plum, orchid, bamboo and chrysanthemum "a picture of four *junzi*." When our motherland was weak and disgraced, the orchid would become the vehicle and symbol for patriots to express their national integrity. While painting orchids, some painters would expose the roots uncovered by mud, so as to express their indignation about the national territory lost or ceded in their times. People love, admire, cultivate and eulogize the orchid, because it can offer an aesthetic pleasure, spiritual comfort and enjoyment to people.

Dendranthema Morifolium

Dendranthema morifolium (Chrysanthemum) is a perennial herb belonging to Dendranthema of Asteraceae. Its large flower has such colors as red, yellow, white, purple, green, pink and compound-color. The shapes of its flower include single-lobe, polyphyll, flat, spherical, long floc, short floc, smooth floc, roll floc, hollow, solid, straight, etc. Its florescence is often in October. Having originally emerged in China, it is planted all over the world. It is one of the ten most famous flowers in China.

In golden autumn when all trees look desolate and their flowers fade away, Chrysanthemum blooms solitarily and arrogantly in spite of frosts. In China, Chrysanthemum is therefore blessed with many noble personal characters, including loftiness, pride, uprightness, elegance, solitariness, uniqueness, exquisiteness, faithfulness, fortitude, fearlessness, etc. Qu Yuan (c. 340–278 BC), a great poet in the period of Warring States, set a precedent of admiring and appreciating Chrysanthemum in his poems. The stanza, "While picking Chrysanthemum beneath the Eastern fence, I rest my gaze upon the southern mountain" by Tao Yuanming (c. 365–427 AD), a pastoral poet in the Eastern Jin dynasty, remains popular even today.

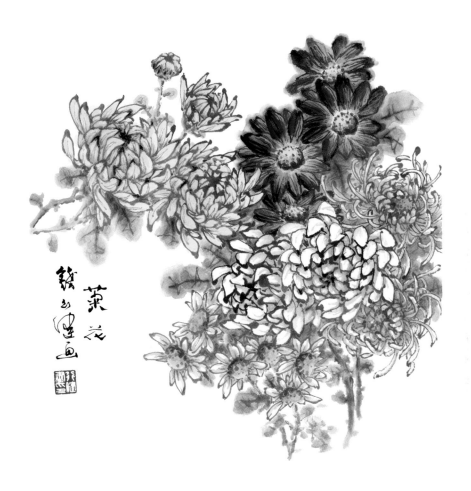

菊花

钱行健画

Chrysanthemum had only one variety (yellow) in its early period, blossoming in October, so people regarded it as a symbol of autumn. However, as Chinese Chrysanthemum cultivation developed for thousands of years, this changed a lot. For example, the Fifth-Month Chrysanthemum emerged in the Song dynasty blossoming in the 5th month of the Chinese lunar calendar. Nowadays, there are many routine planted-varieties including Spring Chrysanthemum, Summer Chrysanthemum, Autumn Chrysanthemum, Winter Chrysanthemum and June Chrysanthemum, July and August Chrysanthemum and September Chrysanthemum. In addition, the shapes and colors of Chrysanthemum are diversified and spectacular.

Not only is Chrysanthemum edible, but also it can be used as medicine. The wine brewed with its flowers, stalks and leaves together with millets is called Chrysanthemum Wine. During the Double Ninth Festival on the 9th day of the 9th month of the Chinese lunar calendar, such festive customs as ascending mountains, wearing cornus officinalis, drinking Chrysanthemum Wine and appreciating Chrysanthemum has existed for a long time.

Gossampianus Malabarica

Gossampianus malabarica is a deciduous large tree belonging to Bombax of Bombacaceae, with its height reaching up to 25 meters. Emerging before the leaves, its large flower is orange. Its florescence lasts from February to April. It emerges in such provinces and regions of China as Fujian, Guangdong, Hainan, Guangxi, Yunnan and the valley of the Jinsha River of Sichuan Province. In addition, it is distributed in Vietnam, Burma, India and Oceania.

In spring, when Gossampianus malabarica is in full blossom, the orange flowers look like burning fires. While passing by Chaozhou and Huizhou (Guangdong Province), Liu Kezhuang (1187–1296), a poet in the Song dynasty, saw such flowers blossoming everywhere. He asked the local people what the name of these flowers was, as well as wrote a poem to describe the spectacular sight.

With thick petals, every Gossampianus malabarica flower looks like a big and strong fellow with a red face, offering one an impression of heroic spirit. Chen Gongyin (1631–1700), one of three most famous scholars south of the Five Ridges in the early Qing dynasty, eulogized the flower in his poem. Since then, the flower has been blessed with another name, "hero flower."

After bearing fruits, the cotton-fiber in Gossampianus malabarica can be made into cotton gown, bedding, pillow-core, etc. Its flowers can be used to brew tea and simmer soup, or as medicine.

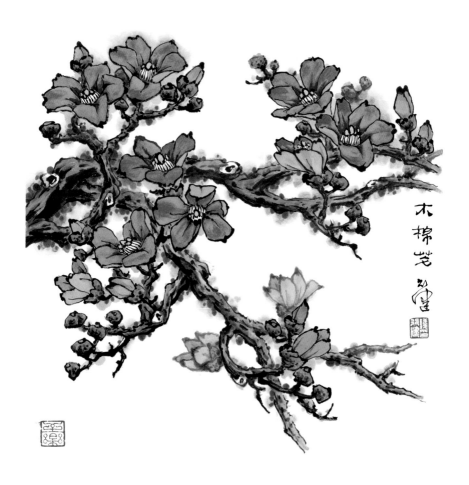

木
棉
花

Hibiscus Mutabilis

Hibiscus mutabilis is a deciduous shrub or small tree belonging to Hibiscus of Malvaceae. Its large flower has such colors as white, light red, red or red-and-white. Its florescence lasts from September to November. Having originally emerged in southwestern China, it is planted all over China.

Hibiscus mutabilis has large and gorgeous flowers, looking like lotuses coming out of water. It is a woody plant growing on land. As it blossoms in late autumn against the bitingly-cold wind, after Frost Descent (one of the 24 traditional solar terms of China), it is reputed as "frost-resistant flower." What is the most wonderful about Hibiscus mutabilis is that its flower will change colors. For example, the color of a Hibiscus mutabilis will turn from snow-white in the morning to light red at noon, and then to dark red at night, just like the face of a lady who has drunk some wine.

Hibiscus mutabilis looks the most spectacular when planted in a group. Having originally emerged in southwestern China, Hibiscus mutabilis has been distributed most widely in Sichuan since the ancient times. In the period of Five Dynasties and Ten States (907–960 AD), Meng Chang (919–965 AD, 934–965 AD on the throne), emperor of the Late Shu Kingdom, had Hibiscus mutabilis planted all over Chengdu. In late autumn, extending for up to 20 kilometers, Hibiscus mutabilises burst open together like colorful brocades as beautiful as clouds, thus having offered Chengdu a title, "Capital of Hibiscus Mutabilises."

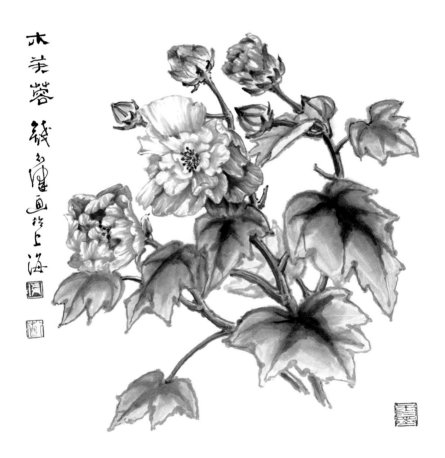

Jasminum Sambac

Jasminum sambac is an evergreen small shrub or Liane shrub belonging to Mirabilis of Oleaceae. Its small flower is white and aromatic. Its florescence lasts from June to October. Having originally emerged in India, it is planted all over China, especially in such provinces and regions as Guangdong, Guangxi, Fujian, Zhejiang, Jiangsu and Yunnan.

Jasminum sambac was brought into China together with Buddhism in the Han dynasty (206 BC–220 AD) about two thousand years ago. In the Buddhist books, Jasminum sambac is also called *Manhua* (hair adornment), because women can use it to adorn their hair. Having seen the local girls of the Li Nationality in Danzhou (present Danzhou, Hainan Province) adorn their hair with jasmine while holding a betel palm in their mouth, Su Shi, an eminent writer in the Song dynasty, composed a poem to vividly depict the local customs of adorning hair with flowers.

During the transition between summer and autumn when it is too hot to bear, the snow-white color and far-reaching fragrance of jasmine usually offer people an illusion of coolness. Liu Kezhuang, a poet in the Song dynasty, associated jasmine with the

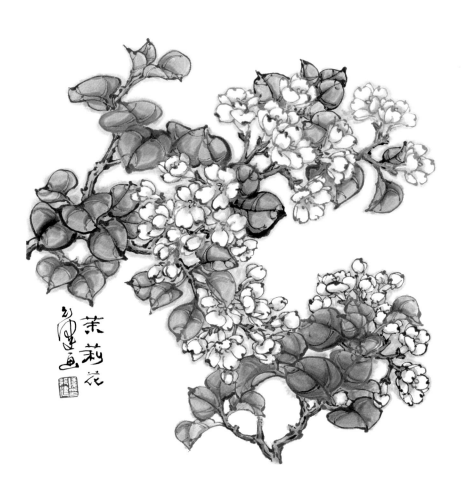

茉莉花

alleviation of heat in his poem: "The flower can fill the room with aroma, and can cool off your body on hot days."

Jasmine is famous for its fragrance. Since the Ming and Qing dynasties, people have often stored tea with jasmine, which is the famous "jasmine tea." China has the largest area of jasmine plantation, making up two-thirds of the total area worldwide. The output of fresh jasmines of China ranks first worldwide, with its concentrations from fresh jasmine flowers selling well in both domestic and overseas markets.

Kalimeris Indica

Kalimeris indica is a perennial herbage. Its small flower has mauve pale petals and a yellow stamen. Its florescence lasts from April to August. Having originally emerged in various parts of China, it is also distributed in India and Hawaii (USA).

With edible tender leaves, Kalimeris indica is a famous edible wild herb. Because of its deliciousness, it was reputed as "ten-*li* (2 *li* = 1 kilometer) fragrance" in the ancient times. Kalimeris indica often grows at the roadside and in the fields, with a very strong vital force. Although it can be seen all over China, its growth in the Kalimeris Indica Prairie in Ningxia Hui Autonomous Region is the most spectacular and vigorous. Located around Yueya Lake of Taole County, Kalimeris Indica Prairie is part of the Erdos Mesa, with an area of grassland of more than 100,000 *mu* (15 *mu* = 1 hectare). Every April and May, on the vast Kalimeris Indica Prairie, one can see layers of Kalimeris indica spread on the boundless desert-sand like an emerald blanket, followed by numerous graceful and sporadically-distributed purple flowers in blossom. They together constitute a spectacular purple sea of flowers, featuring an unparalleled beauty.

The flower of Kalimeris indica is pure, plain and unsophisticated. According to a legend, it is a flower of "happiness" that the fairies in the heaven bestow to the human world. In addition, the flower of Kalimeris indica symbolizes courage and adamancy.

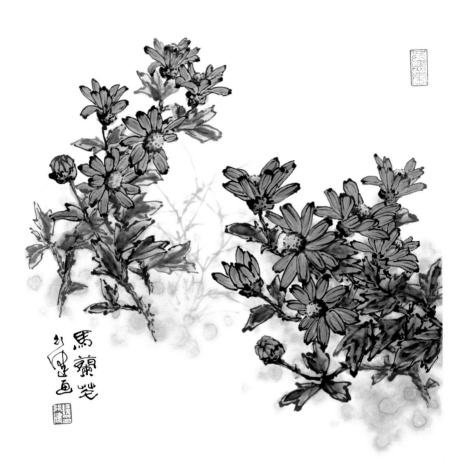

Lagerstroemia Indica

Lagerstroemia indica is a deciduous small tree belonging to Lagerstroemia of Lythraceae. It contains colors of purple, red, light red, and white. Its florescence lasts from June to September. Having originally emerged in central and southern China, India, Malaysia, Australia and other places, it is planted all over the world.

China is one of the places of origin of Lagerstroemia indica, as well as having been its plantation center in the world since the ancient times. In the Tang dynasty, as the Chinese term for Lagerstroemia indica "Zi Wei" was similar to the term for the highest administrative institution in the imperial palace in both pronunciation and spelling, Lagerstroemia indica was widely planted in the imperial court. When Lagerstroemia indica was in blossom, thousands of its flowers formed a conic anthotaxy in groups and clusters to densely cover the tips of clusters of branches. Under the brilliant sunlight, the bright tree illuminated the whole hall. A poet of the Song dynasty praised it in this way, "In midsummer, the flowers of Lagerstroemia indica can redden the whole hall." Therefore, Lagerstroemia indica is also called "full-hall red." If one fondles the tree of Lagerstroemia indica, the branches

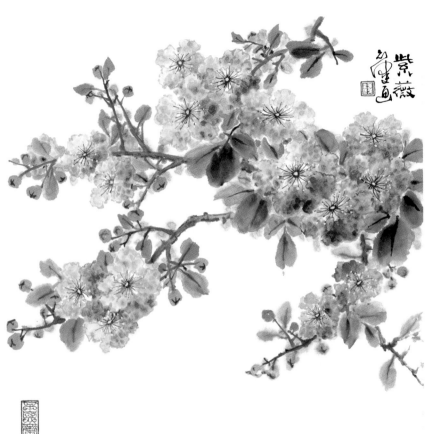

紫薇

47

and leaves will amazingly tremble a bit. Therefore, it is also called Titillating Tree and Itching Flower.

Lagerstroemia indica has a long florescence, lasting from summer to late autumn, as long as 100 days or even half a year. Therefore, it is also called "100-day red." The tree of Lagerstroemia indica has a very long life-span. Many trees of Lagerstroemia indica planted in the Ming and Qing dynasties have been found to still exist today in a perfect state all over China. For example, planted in the early Ming dynasty, a Lagerstroemia indica in Yi Yuan (The Garden of Joy) in Suzhou has a history of more than 600 years.

Lilium

Lilium is a perennially herbaceous plant belonging to Lilium of Liliaceae. It has an underground bulb enclosed with layers of squamae. Its large flowers have such colors as reddish yellow, yellow, white or green. Lilium blooms in summer. Lilium originally emerged in the Northern Hemisphere, while China is the center of distribution for Lilium in the world.

With one of its places of origin in China, the edible and medicinal value of Lilium was applied at a very early time. Lilium has upright and erect stalks, leaves as green as those of bamboos, as well as elegant and graceful flowers shaped like trumpets. Its beauty had already begun to arouse public attention in ancient times. Ode to Lilium, the first song known today, is a poem by Xiao Cha, the third son of Emperor Xuan (519–562 AD) of the Later Liang dynasty of Southern dynasties. He eulogized Lilium like this, "Lilium holds dews or droops low, and faces upward against wind."

In history, the earliest painting of Lilium appeared on the *Painting of Auspicious Flowers* by a painter in the Later Shu State (934–965 AD) in the Period of Five Dynasties and Ten States. Lilium is popular among common people because its rootstalk is

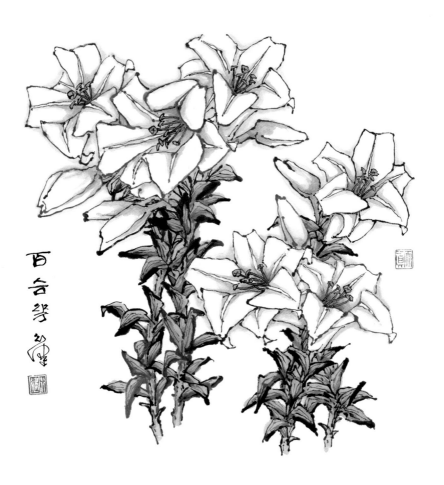

百合花

enclosed with nearly 100 squamae, which can be seen to symbolize one-hundred-year solidarity and unification. Therefore, for thousands of years, it has been regarded as an auspicious flower, and it has often served as the patterns and images for painting-sketches, buildings, furniture, utensils and other objects, denoting luck, auspice, peace and unity. Today, during a wedding, Lilium is often held in the bride's hand.

Magnolia Denudata

Magnolia denudata is a deciduous tree belonging to Magnolia of Magnoliaceae, with a height of up to 15 meters. Emerging before the leaves, its flowers are large, white and fragrant, with its florescence in March. Having originally emerged in the valleys of the Yangtze River, China, Magnolia denudatas are planted throughout northern and southern China. At present, the seeds of Magnolia denudata are brought into various countries and regions worldwide for plantation.

With a long history of plantation in China, Magnolia denudata has white and slightly-greenish flowers as fragrant as orchids. In ancient times, it was planted in front of pavilions, terraces, buildings and towers. Now it usually appears in gardens, and it also grows solitarily or sporadically near factories and mines, or grows on both sides of roads. In northern China, it is planted in ornamental pots. Magnolia denudata is a very popular and precious ornamental plant. If it is planted in a courtyard, its flowers will come out before its leaves emerge in spring. Even if there is only one Magnolia denudata, it will still shade the whole courtyard with its large canopy and give out an omnipresent fragrance when it has grown strong, big and tall. Wang Shizhen

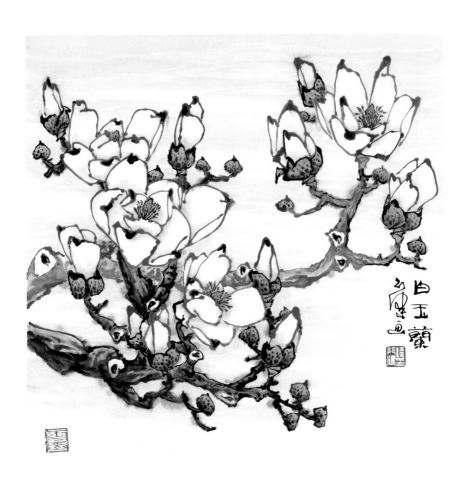

白玉蘭

53

(1526–1590), a litterateur in the Ming dynasty, planted ten Magnolia denudatas in his private garden in Taicang (present city of Taicang, Jiangsu Province). When they were in full blossom, he even depicted them as "reflecting one another like islands against the background of a snow-covered mountain," thus having revealed his wonderful feeling, "as if being located in a world full of white snow."

Magnolia denudata has a life span of more than 100 years. The unfaded flowers of Magnolia denudata can be used to aromatize tea, while the buds of Magnolia denudata can be used as medicine.

Magnolia Liliflora

Magnolia liliflora is a deciduous small tree or shrub belonging to Magnolia of Magnoliaceae. Its large flower has a Vorticella shape, and the color outside is purple or purplish red while the inside is white. Its florescence lasts from April to May. Having originally emerged in central and southern China, it is now planted all over China.

As early as in the Spring and Autumn period (770–476 BC) 2,500 years ago, Magnolia liliflora was planted in the imperial palace of the Wu Kingdom. As its wood has a very good quality, it was often used to build palaces at that time. Magnolia liliflora was highly regarded as a medicine in China at a very early time. From the official tombs of the Western Han dynasty more than 2,000 years ago, the buds of Magnolia liliflora were unearthed as funerary objects, which can serve as a proof of its rarity and value. The buds of Magnolia liliflora look like the head of Chinese brushes, while the flowers of Magnolia liliflora look like small lotus flowers. By seizing these features, Tang dynasty poet Bai Juyi (772–846 AD) wrote, "a purple chalk contains sharp flames, while red rouge dyes small lotuses."

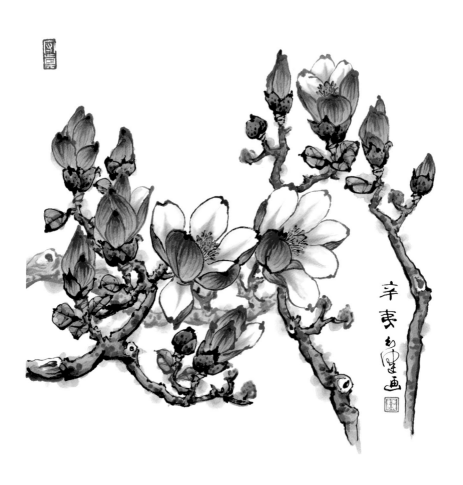

辛夷

In the Tang dynasty, Magnolia liliflora began to be circulated to Japan. In 1790, it was circulated to Britain from Japan. Since then, Magnolia liliflora has been spread all over the world. It is not only a rare ornamental plant, but also essence and spice can be extracted from it, and it can be extensively used as raw material for cosmetics and in such fields as pharmacy.

Magnolia Sieboldii

Magnolia sieboldii is a deciduous small tree belonging to Magnolia of Magnoliaceae. Its flower is white and aromatic, with a florescence lasting from June to July. It is distributed in such provinces and regions of China as Liaoning, Jilin, Hebei, Anhui, Jiangxi and Guangxi, as well as in Korea and Japan.

According to a Chinese ancient legend about Buddhist scripture, there was a fairy in the heaven. One day, when listening to various Bodhisattvas discussing Buddhist doctrines with their disciples, the fairy appeared in its true form and scattered heavenly flowers on the Bodhisattvas and their disciples, so as to test their achievements in Buddhist doctrine. Later, people used this idiom to describe throwing things into the sky and the swirl of many large snow-flakes.

Magnolia sieboldii mostly grows in the crevasses of cliffs, and bursts open amid hazy drifting mists. As it has slender branches with flowers blooming at the top of them, when it is in full blossom, we can see graceful and beautiful flowers with petals swirling against genial breezes. What accompanies the white swaying flowers is an omnipresent and long-lingering fragrance. One cannot help feeling the artistic conception that the above legend has created, thus leading to the beautiful name of "fairy flower."

Magnolia sieboldii is not only a tree suited for appreciation in courtyards, but also its flowers, leaves and seeds can be used to make spices. In addition, it boasts a medicinal value.

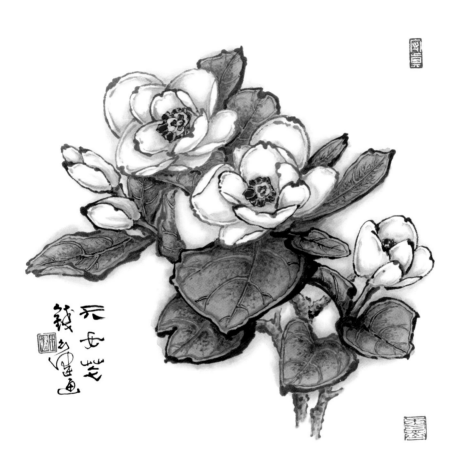

59

Narcissus Tazetta Var. Chinensis (Daffodil)

Narcissus tazetta var.chinensis is a perennial herb belonging to Narcissus of Amaryllidaceae. It has a spherical bulb and small flowers with white petals. With a yellow cup-like sub-corolla inside itself, it is balmy, with a florescence lasting from January to March. It is distributed in southeastern coastal areas of China. It is one of the ten most famous flowers in China.

As a variation of Western Narcissus, Chinese Narcissus was brought to China from Western Asia in the Tang and Song dynasties. Hunan and Hubei provinces were its important centers of distribution. At that time, people already knew how to use the flowers as decorations. While staying in Jingzhou (Hubei Province), litterateur Huang Tingjian (1045–1105) marveled at the beauty of Narcissus there, as well as wrote a poem to commemorate it, likening Narcissus to a spotless fairy walking gracefully on waves. Since then, Narcissus has been called "a fairy on waves." Today, Zhangzhou (Fujian Province) and Chongming Island (Shanghai) are the most famous for the plantation of Narcissus.

In books on the history of flowers in the ancient times, Narcissus is designated as one of the year-end flowers, preceded by Chimonanthus praecox and followed by Prunus mume. At that time, all other trees have turned bare and desolate, and only pines, bamboos, plums, etc. keep it company. Therefore, Narcissus is reputed as one of the "trustworthy friends in winter," and is one of the traditional favorite offerings in Spring Festival.

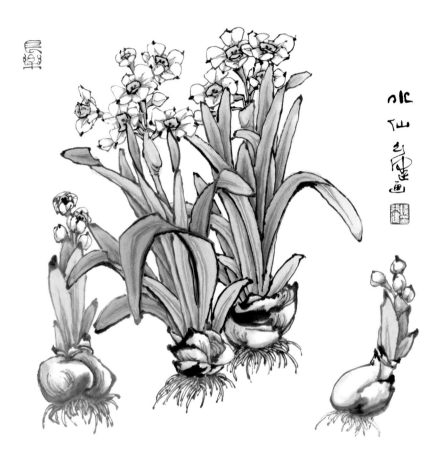

61

Nelumbo Nucifera

Nelumbo nucifera is a perennial hydrophyte belonging to Nelumbo of Nymphaeaceae, with its rhizome (lotus rhizome) growing horizontally in the mud at the bottom of the water, and with its flowers growing at the top of the stem, high above the water-surface. Its large flower has such colors as deep-red, pink, white, light green, and compound-color. Its florescence lasts from June to September. Having originally emerged in China, lotus flowers are distributed in subtropical and temperate zones. It is one of the ten most famous flowers in China.

China has a long history of using and planting lotus flowers. The trace of lotus flowers can be found in the relics of Hemudu Culture (Yutao, Zhejiang Province) 7,000 years ago and Yangshao Culture (Sanmenxia, Henan Province) 5,000 years ago. When lotus flowers are in blossom, one can see a straight and elegant stalk rising from the water, with flowers and leaves above and under it respectively. The graceful and elegant flowers give out a far-reaching fragrance. Since the ancient times, people have always vividly likened lotus flowers to beauties in front of a dresser or out of a bathtub. Zhou Dunyi (1017–1073), a philosopher in the Song dynasty eulogized lotus flowers as "a noble flower remaining

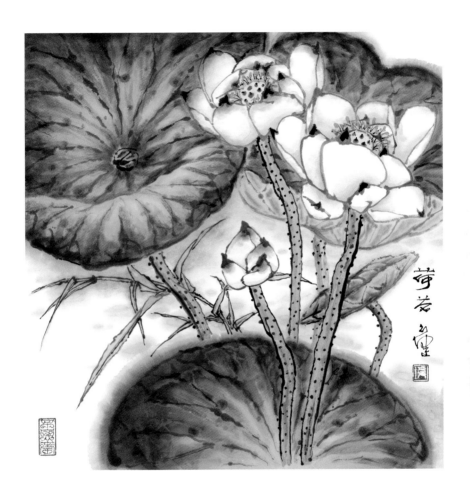

unpolluted even though having come out of silts" and "*junzi* of the flowers." Since then, the fame of the lotus flower has been spread far and wide. According to the customs in the lower reaches of Yangtze River, the 24th day of the 6th month of the Chinese lunar calendar is regarded as the birthday of lotus flowers. The lotus flower is therefore reputed as "a flower god in the 6th month of the Chinese lunar calendar."

In China, the lotus flower has many homophonic connotations, e.g. it stands for the lovesickness between lovers, the love between the male and the female, and the lifelong love between husbands and wives. This can not only be seen in folk songs, but also is extensively applied in artworks and paintings. In the Tang and Song dynasties, lotus flowers, osmanthus and rohdea japonica were often adopted as the artistic patterns printed on fabrics, connoting "remaining rich and honor for thousands of years." In the Ming and Qing dynasties (1368–1911), lotus flowers and carp were often adopted, connoting "surplus year after year," or mandarin ducks and lotus flowers were adopted, connoting "remaining prosperous all the time." These can be regarded as symbols of auspice, peace and luck.

Nymphaea Tetragona

Nymphaea tetragona is a perennial aquatic herbage belonging to Nymphaea of Nymphaeaceae. In the shape of a horseshoe, its leaves often surface on the water. Its flowers grow at the apex of its shoots, surfacing on the water. In addition, its large flowers are normally white, blooming in the afternoon, closing at sunset, with a florescence lasting from May to September. Having originally emerged in eastern Asia, it is distributed in China, Japan, Korea, India, Siberia and Europe.

After Nymphaea tetragona (water-lily) blossoms in the daytime, its petals will hang at night as if sleeping. As mentioned in the book *Miscellaneous Morsels from Youyang* in the Tang dynasty, this peculiar phenomenon was seen in Nanhai (present Nanhai, Foshan, Guangdong Province): "The water-lilies in Nanhai face the sun in the daytime, and lower themselves into the water at night." The Latin term of Nymphaea plants originates from a Latin word, Nymph, meaning a water goddess. In Western culture, water-lily is regarded as the incarnation of holiness and beauty, just like Chinese lotus flowers. From the 4th century, August 5 was fixed as the birthday of water-lily. Ancient Egyptian people called water-lily "a bride of the Nile," and regarded it as a symbol of sun. Water-lily was planted as early as more than 2,000 years ago.

Water-lily has gorgeous, delicate and enchanting flowers. Looking like fairies walking gracefully on waves in a pond, they can always fascinate and entertain tourists.

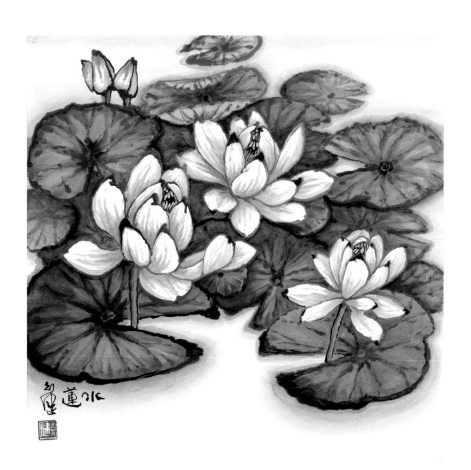

Osmanthus Fragrans

Osmanthus fragrans is an evergreen broadleaved tree belonging to Osmanthus of Oleaceae. Its small flower has such colors as milk-white, yellow, orange-red and so on. Its florescence lasts from September to October. Its common varieties include *jin'gui*, *yin'gui*, *dan'gui*, *sijigui*, etc. Having originally emerged in southwestern and central China, it is now extensively planted in the valley of the Huaihe River and its southern regions. It is one of the ten most famous flowers in China.

In southern China, osmanthus trees can grow both high and stout. Whenever the florescence comes in autumn, the flowers blossoming all over the trees can give out a far-reaching and strong fragrance, drifting away above people's heads. Some flowers will fall onto the ground with gusts of breezes. In particular, in mid-autumn, on the night of the 15th day of the eighth month of the Chinese lunar calendar, under a bright moon, the fragrance appears as if having drifted from the clouds, and the flowers look as if having fallen from the moon. This scene always reminds one of a legend about Chang'e, a beautiful fairy living in the Osmanthus Palace in the moon. In addition, Li Yu (1611 –1679), a writer in the Qing dynasty, confirmed the legendary

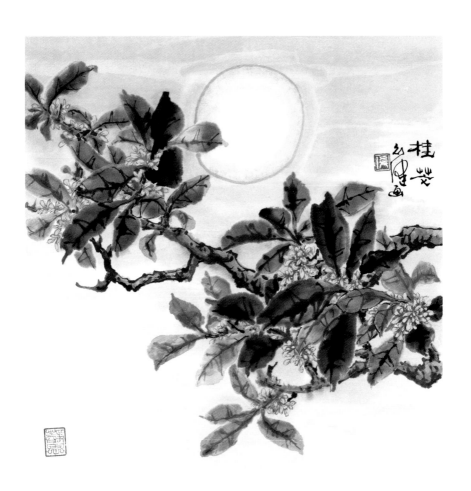

桂花
乙酉
健画

story in *A Miscellanies Written in a Leisurely Time*, "No other flowers blossoming in autumn are more fragrant than osmanthus, with its tree coming from the moon and its fragrance from the heaven."

Since ancient times, people have thought highly of this unsophisticated weathercock and characteristics. In the frigid, desolate and listless season, it stands upright solitarily and proudly, and blossoms against frosts, with its countless buds and far-reaching fragrance. It appears so elegant, noble, immaculate, and lonely.

Paeonia Lactiflora

Paeonia lactiflora is a wild perennial herb belonging to Paeonia of Ranunculaceae. Its large and balmy flower contains colors of white, yellow, red and purple. Its florescence lasts from May to August. It originally emerged in northern China, Siberia and Japan.

The tuberous root of Paeonia lactiflora can be used as medicine. As it looks like peony (both belonging to Ranunculaceae), ancient people called peony and Paeonia lactiflora "king of flowers" and "prime minister of flowers" respectively. However, they also have obvious differences: peony is woody while Paeonia lactiflora is herby; peony blossoms in March in spring, while Paeonia lactiflora blossoms at the end of spring. In addition, unlike peony, Paeonia lactiflora is very cold-resistant, so it is mostly distributed in northern China.

Large and gorgeous, the Paeonia lactiflora flower is one of the most beloved flowers of Chinese people. Chao Buzhi, a poet in the Song dynasty, sang a high praise of it in his poem. Paeonia lactiflora boasts a long history of plantation. Chang'an (Xi'an, Shaanxi Province) in the Han dynasty, Yangzhou (Jiangsu Province) in the Tang and Song dynasties and Bozhou (Anhui Province) in the Ming dynasty were once the centers of its plantation and appreciation. Just like peony, when Paeonia lactiflora was in blossom, all the people were crazy about it. Today, it is still a very popular flower in various parks or flowerbeds in China.

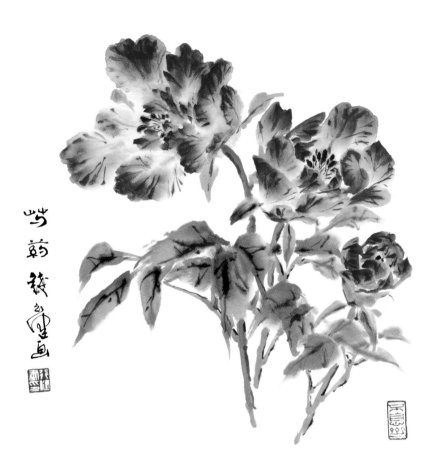

Paeonia Suffruticosa

Paeonia suffruticosa is a deciduous small shrub belonging to Paeonia of Ranunculaceae. Its large flower has such colors as yellow, white, red, pink, purple, black, green, blue, and compound-color. Its florescence lasts from April to May. Having originally emerged in China, it is distributed all over China. In particular, it is very appropriate to plant Paeonia suffruticosa in the valleys of the Yangtze River, Huai River and Yellow River. It is one of the ten most famous flowers in China.

As one of the most favorite flowers of Chinese people, peony appears magnificent and extremely elegant. Li Bai (701–762 AD), a famous Chinese poet in the Tang dynasty, compared Concubine Yang, empress of Emperor Xuanzong (685–762 AD, 712–756 AD on the throne) to the peonies in Chang'an, the capital of the dynasty, in one of his poems still popular today.

In the Northern Song dynasty (960 AD–1127), peony was called "king of flowers," and its center of plantation was transferred from Chang'an to Luoyang, since which the peony in Luoyang has ranked first nationwide. After the Southern Song dynasty (1127–1279), such regions as Chenzhou (present Huaiyang, Henan Province), Yuezhou (present Shaoxing, Zhejiang

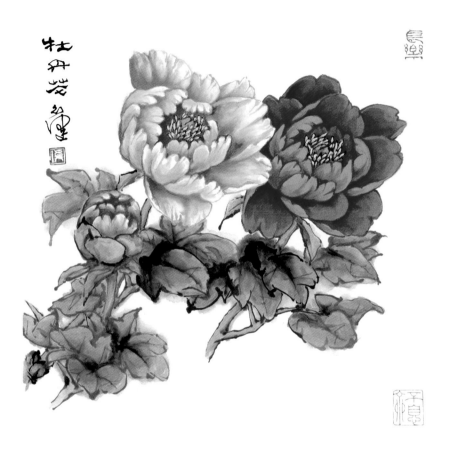

牡丹花

73

Province), Tianpeng (present Pengzhou, Sichuan Province), Bozhou (Anhui Province), and Caozhou (present Heze, Shandong Province) became famous for planting peonies in succession.

Peony is regarded as a flower blossoming in the most suitable climate. In the Grain Rain Season (late April and early May), the spring cold has vanished, while the hot summer days have not approached, with the year's most genial and agreeable climate. This period is exactly when peonies burst open. Therefore, since the ancient times, people have preferred to appreciate peonies while walking during this period.

Phalaenopsis Amabilis

Phalaenopsis amabilis is a perennial herb belonging to Phalaenopsis of Epidendroideae. Its large flower has such colors as white, yellow, orange, red, purple, blue and multicolor. Its florescence lasts from April to June. Having originally emerged in Asia, Phalaenopsis amabilis is chiefly distributed in low-latitude tropical sea-islands. The Phalaenopsis amabilis emerging in the forests and Green Island in eastern Taiwan is the most famous. Nowadays, it is extensively planted worldwide.

Phalaenopsis amabilis is blessed with a beautiful and elegant pose. Its original seed was discovered in 1750. Through cross-breeding and selective cultivation, numerous varieties of it have been developed nowadays. In early spring, straight and elegant stalks stand on shiny, emerald leaves, with the number of flowers ranging from seven to thirteen. One flower after another blossoms from the base upward, with such colors as purely-white, light-yellow, pink, light-purple, orange-red and azure. Some flowers look as if embroidered with patterns, while some look as if sprayed with colorful spots. They all look gorgeous and resplendent. All the flowers in blossom look like a group of colorful butterflies flying into the sky gracefully in ranks, offering so poetic,

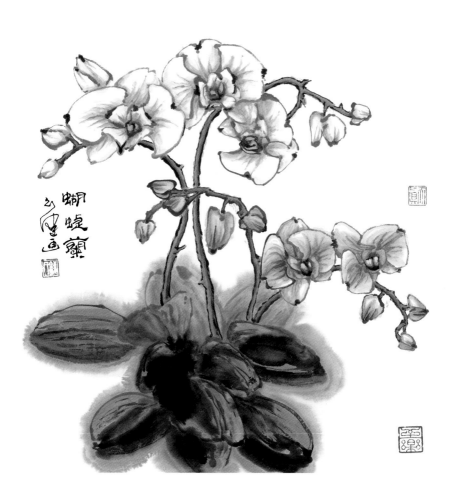

蝴蝶蘭
乙亥年畫

picturesque and illusionary a sight that one cannot help marveling at it.

Beautiful Phalaenopsis amabilis is considered capable of bringing good luck to people. It has various connotations and symbolizations, e.g. yellow Phalaenopsis amabilis symbolizes prosperous undertakings and business; white Phalaenopsis amabilis symbolizes pure love and valuable friendship; red-heart Phalaenopsis amabilis symbolizes good luck and permanent love; red Phalaenopsis amabilis symbolizes a smooth official career and a rich and consummate life; stripe-dot Phalaenopsis amabilis symbolizes having success in any case and at any time; mini Phalaenopsis amabilis symbolizes a happy angel and the prime of youth, and so on. As a genuine rarity among the tropical orchids, Phalaenopsis amabilis is reputed as "an empress among orchids."

Philadelphus Pekinensis

Philadelphus pekinensis is a deciduous shrub belonging to Philadelphus of Saxifragaceae. Its flower is milky-white and lightly fragrant, with its florescence in June. Having originally emerged in western and northern China, especially in the mountainous region of Beijing, it is now planted in the gardens of various large cities. In addition, it is also distributed in North Korea.

Discovered earliest in Qingcheng Mountain, Sichuan Province, Philadelphus pekinensis was readily transplanted by Chengdu people to their courtyards. In the period of Tianshen (1026–1031) in the Northern Song dynasty, having found such a beautiful flower, some local officials offered it to Emperor Renzong (1010–1063, 1023–1063 on the throne) in the capital city (Bianjing, present Kaifeng, Henan Province). Emperor Renzong took a fancy to it at the first sight of it. He not only had it planted in imperial gardens, but also renamed it "peaceful holy flower," abbreviated as "peaceful flower" by the people in the Song dynasty. After that this flower became famous all over China, and it began to be planted in northern China. It is said that the Philadelphus pekinensis growing in the Imperial Garden in the Palace Museum, Beijing, today is a relic of the Ming dynasty (1368–1644).

Philadelphus pekinensis has dense branches and leaves. Many of its white, fragrant, elegant and beautiful flowers grow in a group. It can be planted in clusters, in patches or on a platform. Its tender leaves are edible.

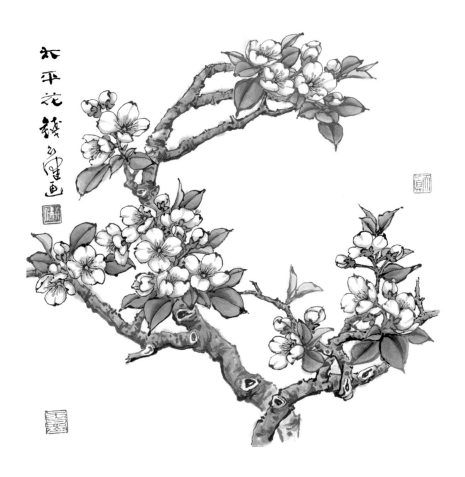

Potentilla Fruticosa

Potentilla fruticosa is a deciduous shrub belonging to Potentilla of Rosaceae. Its small yellow flower has five petals. Its florescence lasts from May to July. It emerges in such provinces and regions in China as Liaoning, Northern China, Northwestern China, Sichuan and Yunnan, while it is also distributed in such countries and regions as Central Asia, Caucasia, Siberia, Japan, Mongolia, Korea, Europe and North America.

With five petals and a golden color, the flower of Potentilla fruticosa is shaped like a plum flower. Whenever they blossom in summer, Potentilla fruticosas constitute a vast and boundless picturesque sight like golden rosy-clouds drifting on a vast prairie, lying very close to one another. In northwestern grazing regions, in spring, the newborn tender and fat branches and leaves of Potentilla fruticosas can serve as food for horses, sheep and cattle. As they contain a rich amount of coarse proteins and fats, Potentilla fruticosas (boasting a strong ability for propagation) have become a feeding plant as a replacement of scarce pasture.

With a compact stalk, gorgeous flowers and a long florescence, Potentilla fruticosa is a desirable species of tree for flower appreciation. It can not only be planted in gardens of high mountains or rocks, but also can be planted on fences. The leaves and flowers of Potentilla fruticosa can not only serve as a tea, but also can be used as medicine.

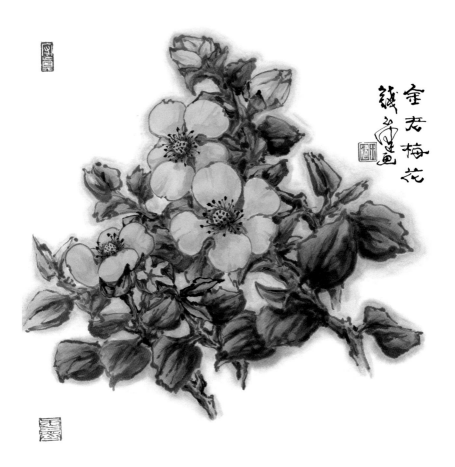

金老梅花
錢君匋畫

81

Prunus Mume

Prunus mume is a deciduous small tree belonging to Prunus of Rosaceae. Its small flower has five petals, with such colors as white, pink, red, purple, light green, and primrose as well as a faint scent. In Yangtze River Vally, its florescence lasts from December to the next March. Its varieties suitable for appreciation include Large Red Plum, Taige Plum, Zhaoshui Plum, Green-Calyx Plum and Longyou Plum. Having originally emerged in China, it is chiefly distributed in the valley of the Yangtze River and southwestern China. It is one of the ten most famous flowers in China.

In the opinion of Chinese people, plum is a peculiar tree symbolizing lofty character and leisurely charm. It boasts a perfect spirit, glamour, pose, aroma and color. The most impressive feature of plum is that it blossoms against frost, snow and frigidity in desolate late winter and early spring. Thanks to its tough, tenacious, courageous and persistent characteristics as well as its identity as the messenger of spring, or even the token of spring, it has been highly eulogized for a long time, and even regarded as the spiritual symbol of the Chinese nation.

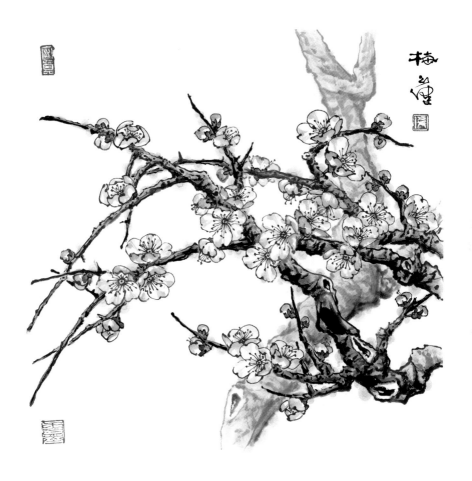

Thanks to the abovementioned characteristics of plum, Su Shi of the Song dynasty reputed it as one of "the three things beneficial for tempering one's willpower" together with thin bamboos and textured stones. Since the Song dynasty, people have regarded pine, bamboo and plum as "three trustworthy friends in winter." In addition, plum, orchid, bamboo and chrysanthemum are regarded as "four *junzi* among flowers." Furthermore, plum is reputed as "a lofty friend" and "an upright guest."

Prunus Triloba

Prunus triloba is a deciduous shrub or small tree belonging to Prunus of Rosaceae. The flowers of different varieties have different sizes, with such colors as purplish red, maroon, light red and whitewash. Its florescence lasts from March to April. Having originally emerged in China, it was distributed in such provinces as Heilongjiang, Hebei, Shanxi, Shandong, Jiangsu and Zhejiang. It is now planted all over China.

The leaves of Prunus triloba look like those of elms, while the original single-petal Prunus triloba has small and pink flowers with five petals, just like plum flowers. However, through long-term plantation, Prunus triloba has diverse varieties. For example, there is a multi-petal Prunus triloba with brown and large flowers, also called "large-flower Prunus triloba." For another example, some varieties even have more than 100 petals, which is far from what plum flowers are like.

Prunus triloba loves sunlight and resists coldness and aridity, without a strict requirement for soil and with a strong adaptability to the environment. Therefore, it grows well and is universally planted in northern China, where it is deeply loved by northern people for flower appreciation in spring. On slopes or in gardens where Prunus trilobas grow in a group, all the flowers of Prunus triloba will constitute a sea of colorful flowers, offering one a sense of being surrounded by rosy clouds.

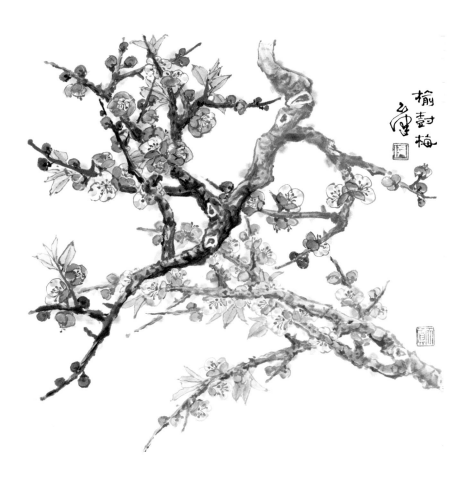

榆葉梅

Rhododendron Anhweiense

Rhododendron anhweiense is an evergreen shrub and a small tree belonging to Rhododendron of Ericaceae. Its large flower has such colors as white, pink and red. Its florescence lasts from April to June. Having originally emerged in China, Rhododendron anhweiense is distributed in such provinces and regions in China as Anhui, Zhejiang, Jiangxi, Hunan and Guangxi.

Rhododendron is reputed as "Xi Shi (one of the four famous beauties in ancient China) among flowers." Gorgeous Rhododendron anhweiense is a special variety among Rhododendrons. Growing in valleys or forests with an altitude of 1000 to 2000 meters, it is also called "rose on high mountains."

Huangshan Mountain, Anhui Province is the chief place of origin of Rhododendron anhweiense. Beside the cliffs in Lotus Peak of Huangshan Mountain with an altitude of 1830 meters, a Rhododendron tree grows today, with its more than 1000-odd pink and white flowers blossoming every spring and summer. One cannot help marveling at its beauty. Compared with other azaleas, Rhododendron anhweiense has six to more than ten

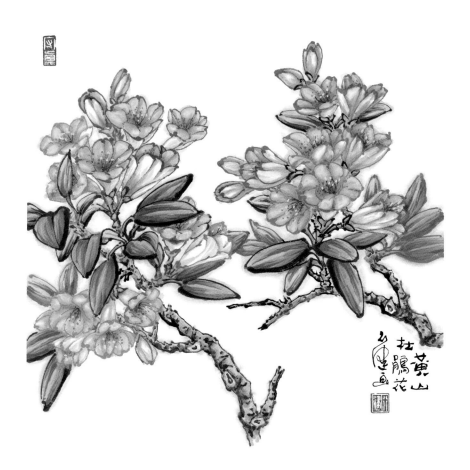

flowers instead of two to six flowers on every cluster. Therefore, when Rhododendron anhweiense is in blossom, red flames will illuminate the entire mountain and valley, offering a spectacular sight.

Meandering in the cliff-crevasses of high mountains, the roots of Rhododendron anhweiense cling to rocks tenaciously in spite of any bad weather. It embodies a spirit of firmness, toughness, and heroic struggle, which has won the heartfelt admiration of people.

Rhododendron Simsii

Rhododendron simsii is an evergreen tree and an evergreen or deciduous shrub belonging to Rhododendron of Ericaceae. The flowers have colors of red, purple, yellow, white, light-blue, light-green and so on. It blossoms in spring and summer. Having originally emerged in China, it is chiefly distributed to the south of the Yangtze River as well as in western China, with Yunnan Province as its center of distribution. It is one of the ten most famous flowers in China.

Rhododendron simsii is also called *Yingshanhong* (flowers capable of reddening a mountain). Every April and May, when people hear cuckoos (from a remote southern place) crowing, these flowers will blossom in full swing. With the red and purple azaleas as gorgeous as evening clouds, the mountain looks fiery all over. Therefore, the flower has the above two designations. However, the colors of azalea are not limited to red. Instead, it has various colors.

In the Tang dynasty, after having begun to be planted in cities, wild azaleas began to arouse the attention of the people, especially the literati. Since then azaleas have enjoyed a worldwide fame. Bai Juyi, a famous poet at that time, preferred azaleas very

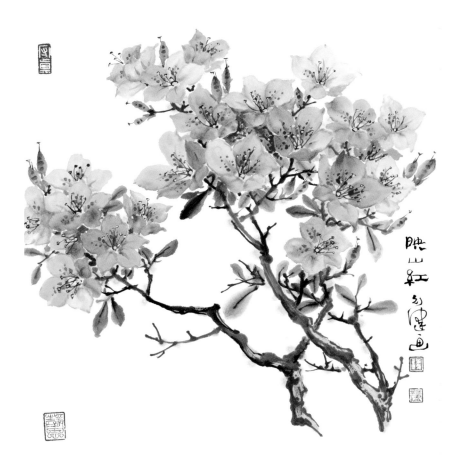

映山红
石伊堂画

91

much. He would transplant azaleas to wherever he served as an official. As recited by him in a poem, "Azaleas look like Xi Shi." In the poem, he likened azaleas to Xi Shi, a famous beauty in the Spring and Autumn Period. Therefore, azalea has been always known as "Xi Shi among flowers" since then.

There is an azalea aged over 500 years in Yunnan Province, reaching a height of 25 meters. In spring, its lush crown offers a nice shade, and its gorgeous flowers are as beautiful as rosy clouds. One cannot help marveling at its beauty.

Rosa Chinensis

Rosa chinensis is an evergreen or semi-evergreen shrub belonging to Rosa of Rosaceae, with aculei on its stem, as well as large flowers. The flowers of its original varieties have the colors from deep-red to light-red, while the flowers of its mutations have such colors as yellow and white. Its flower is aromatic. Its florescence lasts from April to November. Having originally emerged in China, it is planted all over the world. It is one of the ten most famous flowers in China.

Rosa chinensis has a long florescence. For example, in Jiangsu and Zhejiang provinces, it blooms continuously from spring to autumn. In some regions, it blooms all the year round. Its flower has a gorgeous color and strong aroma. In the eye of many people, no other flower in the world can match Rosa chinensis with these advantages. It is really rare for a flower to appear all the year round and burst open against snowy and freezing winter. Therefore, it can be easily distinguished from any other Rosa plant.

Bright-red Rosa chinensis is an original species of Rosa chinensis. Bright-red Rosa chinensis of a fine variety was selected for the Beijing Olympic Games in 2008. Called "Chinese red,"

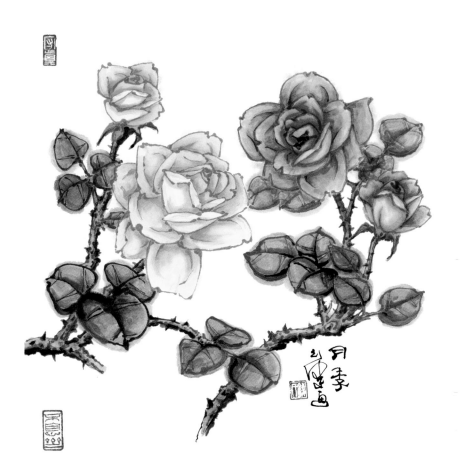

月季

it was used as a bouquet for awarding prizes. Every bouquet consisted of nine pieces of bright-red Rosa chinensis. As its bright-red has a strong Chinese characteristic, and the number 9 connotes absolute superiority, it left a deep impression on people.

Chinese rose exerted a great influence on the cultivation of novel Rosa varieties worldwide. Since the middle 19th century, countless presently-popular varieties with large flowers and gorgeous color have come into being, through the repeated cross-breeding between Rosa chinensis (Chinese Rose) and Rosa rugosa (European rose).

Rosa Rugosa

Rosa rugosa is an evergreen or semi-evergreen shrub belonging to Rosa of Rosaceae. Its stalks are densely grown with thorns. Its large flower has such colors as purple, pink, white, and green as well as a strong fragrance. Its florescence lasts from April to June. Having originally emerged in the temperate zone of China, it is planted all over the world.

As recorded in an ancient book, there were wild Rosa rugosas growing in Leyouyuan Garden in the southern suburb of Chang'an (present Xi'an), the capital of the Western Han dynasty (206 BC–25 AD) more than 2,000 years ago. Probably, the artificial plantation of Rosa rugosa started from that time. As a famous ornamental plant, Rosa rugosa has an agreeable shape and a gorgeous color, known as one of the "three outstanding flowers of rose" together with Rosa multiflora and Rosa chinensis of the same genus. However, what makes Rosa rugosa different from the other two is that it has thorny branches, so it is also called "thorny flower" and "assassin." What makes it more impressive is that Rosa rugosa is so aromatic that it was also called "lingering flower" in the ancient times, meaning that its aroma would linger for a long time.

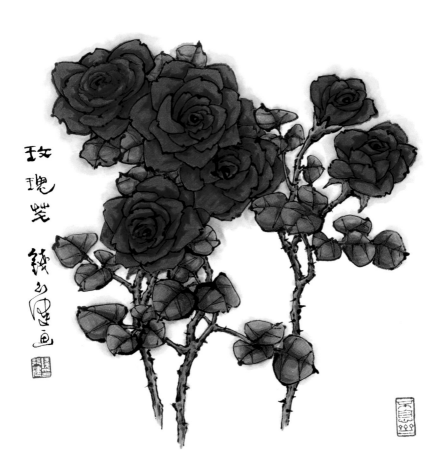

玫瑰花

铁如唐画

Since ancient times, Rosa rugosa has been regarded as the symbol of beauty and love. Today, rose is regarded as the incarnation of love, peace, friendship, courage and dedication. Lovers prefer to use it as a token of love, whether in the East or the West.

Rosa rugosa is an important raw material for producing essential oil. Three tons of rose petals are required as raw material to produce one kilogram of rose oil. The market price of the oil is higher than that of gold of the same weight. In addition, rose flowers can be used to brew tea, make wine, beautify faces, etc. It can also be used as medicine.

Saussurea Involucrata

Saussurea involucrata is a perennial herb belonging to Saussurea of Asteraceae. It grows in the rock-crevasses below the snow line of Tianshan Mountain of Xinjiang Uygur Autonomous Region. Its large flower looks like a lotus with a strong aroma. The growing period from seed-germination to blossom needs five years, its florescence lasts from July to August.

Bogda Peak, as the highest peak of Tianshan Mountain (5445 meters high), is covered with snow all the year round. Below the snow line with an altitude of 4000 meters or so, the temperature is dozens of degrees Celsius below zero. Under such a freezing climate, most plants cannot survive at all. However, Saussurea involucrata is tough enough to grow where the air is so thin, oxygen is so scarce and the temperature is so low. It bursts open against frost and snow, thus having earned the high praise of people of various ethnic groups. With snow as its partner, pure and noble Saussurea involucrata has been regarded as a rare flower standing proudly and straightly on snow-covered Tianshan Mountain. Its mysterious, noble, pure and natural characteristics have become the incarnation of Tianshan, or even the soul of Tianshan.

Thanks to its unique survival propensity and growth environment, Saussurea involucrate boasts a very high medicinal value. With a special pharmacological function and an unusual medicinal value, it is known as "king of herbs" and "a top medicine."

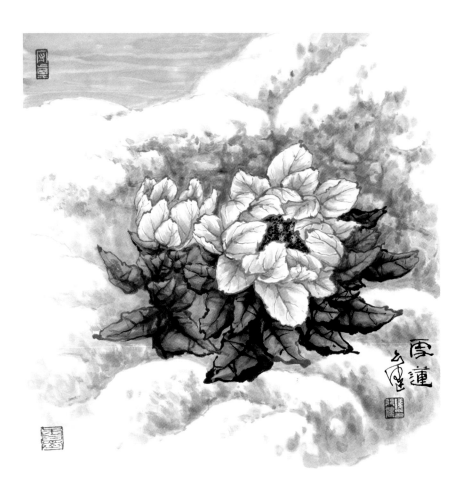

Syringa Oblata

Syringa oblata is a deciduous shrub or small tree belonging to Syringa of Oleaceae. Syringa oblata has a small-shaped flower, with colors of purple, mauve, royal-purple and white (white Syringa oblata is a mutation). In addition, the flower is fragrant, with an aromatic corolla-tube as slim as a nail. It has a florescence lasting from April to May. Having originally emerged in northern China, it is extensively planted nowadays.

By the Tang and Song dynasties, Syringa oblata had already been extensively planted in China. In late spring, Syringa oblata begins to blossom. At first glance, slim buds look as if intertwined, so ancient people often called them Lilac Knot and Lovesick Knot, and regarded them as a symbol of love. As recited by a poet in the Tang dynasty, "Making oaths together in front of interwoven branches; exchanging notes under a lilac tree." Therefore, Syringa oblata is always reputed as a "flower of love" and "tree of happiness."

In warm spring, young people will pick lilacs blossoming on mountains and present them to their lovers, so as to express their loyalty to love. In some places, lilac flowers are regarded as a token of love-promise and a symbol of a wedding. After an

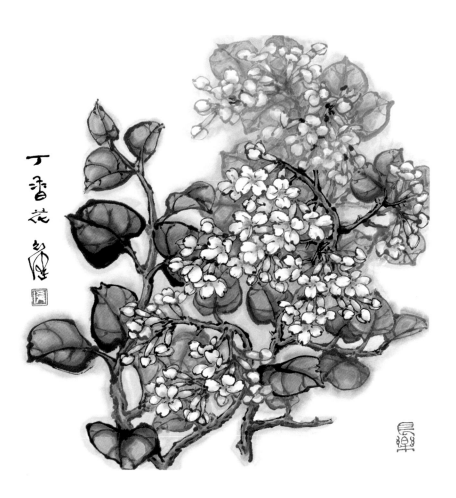

丁香花

engagement, the female will send a bunch of lilacs to the male through a go-between to express her agreement to the marriage, while the male will place the bunch in the bridal chamber, and must fix an auspicious date for marrying the bride before the flowers fade away. Nowadays, this tradition still exists in quite a few areas of China.

Tulipa Gesneriana

Tulipa gesneriana is a perennial bulb herb belonging to Tulipa of Liliaceae. Its large flower is cup-shaped, bowl-shaped, oval-shaped, spherical, bell-shaped, choanoid or lily-shaped. It has such colors as white, pink, magenta, purple, brown, yellow, orange, single-color or compound-color, with a florescence lasting from March to May. Having originally emerged in the Qinghai-Tibet Plateau in China, Turkey, Iran and Mid-Asia, it is planted all over the world.

The flower was praised by Li Bai (a famous poet in the Tang dynasty) in his poem, "Mellow wine with tulip in lanling." In addition, the medicinal value of tulip was highly regarded in the Tang dynasty. In the 16th century, as an ornamental plant, tulip was circulated to Europe from Turkey. In the 17th century, "tulip craze" came into being in Europe, and it was regarded as "a magic flower" and reputed as "a flower-empress in the world." Since then, the Netherlands has become the center of planting and exporting tulips.

The tulip was brought back to China in the 19th century. It can be found in many courtyards in various parts of China today. The tulip emits its charm again on the Qinghai-Tibet Plateau

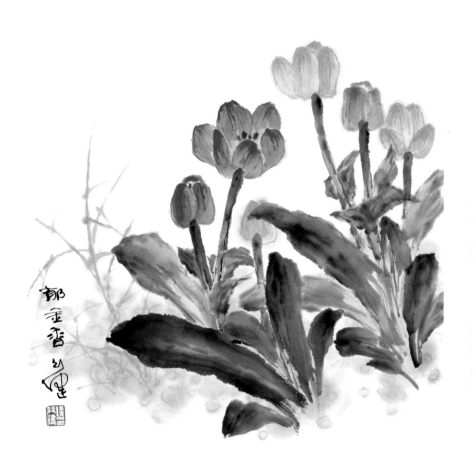

郁金香

(its hometown) again. Since 2002, many tulip festivals have been held in succession in Xining, Qinghai Province. With a unique shape and a gorgeous color, the tulip is endowed with such moral meanings as triumph, desirability, philanthropy, elegance, nobility and intelligence. In particular, a red tulip is always the symbol of fervent love. Every Valentine's Day, in addition to rose, tulip is also the best choice for young males and females to express their love.

Viburnum Macrocephalum

Viburnum macrocephalum is a deciduous or semi-evergreen shrub belonging to Viburnum of Caprifoliaceae. Its large flower is white and faintly aromatic. Its florescence lasts from April to May. Having originally emerged in China, it is distributed in such Chinese provinces and regions as Jiangsu, Zhejiang, Shandong, Henan, Sichuan, Gansu, Jiangxi, Hunan, Hubei, Guizhou and Guangxi.

Viburnum macrocephalum boasts a unique charm. While in blossom, the entire tree looks like a huge white flower-ball from the distance. In the vicinity, one can see the flower-ball consists of countless huge flower-discs. Closer still, one finds every flower-disc consists of eight flowers encircling the stamen in the middle. If observing more carefully, one will find the stamen consists of numerous pearl-like small-flowers. The flower is as clean and white as a fine jade.

The record about Viburnum macrocephalum emerged as early as the Han dynasty. There was a Viburnum macrocephalum growing in a special house built by local people in east of Yangzhou. According to a folk legend, Emperor Yang (569–618 AD, 604–618 AD on the throne) of the Sui dynasty had the Great

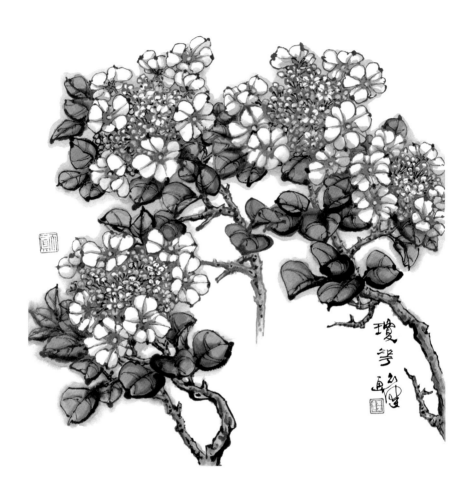

Canal built for him to appreciate Viburnum macrocephalum to Yangzhou. While serving as the governor of Yangzhou, Ouyang Xiu (1007–1072) of the Song dynasty had an Unparalleled Pavilion built for Viburnum macrocephalum. From a poem by a poet of the Song dynasty, we can see that the Viburnum macrocephalum of Yangzhou enjoyed nationwide fame at that time. However, Viburnum macrocephalum is not a specialty of Yangzhou, because it has been discovered in succession in such provinces as Zhejiang and Shaanxi. In the 19th century, Viburnum macrocephalum began to go abroad, and has been gradually planted all over the world since then. Today, in Yangzhou and Kunshan in Jiangsu Province, there are "kings of Viburnum macrocephalum" at the age of several hundred years, which attract innumerable tourists to appreciate their beauty.

Dynasties in Chinese History

Xia Dynasty	2070 BC – 1600 BC
Shang Dynasty	1600 BC – 1046 BC
Zhou Dynasty	1046 BC – 256 BC
Western Zhou Dynasty	1046 BC – 771 BC
Eastern Zhou Dynasty	770 BC – 256 BC
Spring and Autumn Period	770 BC – 476 BC
Warring States Period	475 BC – 221 BC
Qin Dynasty	221 BC – 206 BC
Han Dynasty	206 BC – 220 AD
Western Han Dynasty	206 BC – 25 AD
Eastern Han Dynasty	25 AD – 220 AD
Three Kingdoms	220 AD – 280 AD
Wei	220 AD – 265 AD
Shu Han	221 AD – 263 AD
Wu	222 AD – 280 AD
Jin Dynasty	265AD – 420AD
Western Jin Dynasty	265 AD – 316 AD
Eastern Jin Dynasty	317 AD – 420 AD
Northern and Southern Dynasties	420 AD – 589 AD
Southern Dynasties	420 AD – 589 AD
Northern Dynasties	439 AD – 581 AD
Sui Dynasty	581 AD – 618 AD
Tang Dynasty	618 AD – 907 AD
Five Dynasties and Ten States	907 AD – 960 AD
Five Dynasties	907 AD – 960 AD
Ten States	902 AD – 979 AD
Song Dynasty	960 AD – 1279
Northern Song Dynasty	960 AD – 1127
Southern Song Dynasty	1127 – 1279
Liao Dynasty	916 AD – 1125
Jin Dynasty	1115 – 1234
Xixia Dynasty	1038 – 1227
Yuan Dynasty	1279 – 1368
Ming Dynasty	1368 – 1644
Qing Dynasty	1644 – 1911